D0941257

ART CENTER COLLEGE OF DESIGN

3 3220 00171 2749

Art Center College of Design
Library
1700 Lida Street
Pasadena. Calif. 91103

Portfolio Latinoamericano

779.998
A394p
1997

Mario Algaze

Portfolio Latinoamericano

Edited by Michael Koetzle

Art Center College of Design
Library
1700 Lida Street
Pasadena. Calif. 91103

Gina Kehayoff
Munich

Copyright © 1997 by Gina Kehayoff, Munich

All rights reserved.
No part of this book may be used or reproduced in any manner
whatsoever without written permission, except in the case
of brief quotations embodied in critical articles or reviews.

For information please write to the publisher:

Gina Kehayoff Verlag KG
Herzogstraße 60
D-80803 Munich

Art Director Lennart Jauch
Page Makeup Patrick Tümmers / Publice, Munich
Duotones by Brend'amour, Munich
Printed and bound in Germany by Lindner, Munich

This book is published with editing assistance from
Charlotte von Wangenheim.

ISBN 3-929078-66-X

Runaway's End

Only three years ago, thinking about Mario Algaze's photographs, I asked myself out loud: Where does Latin America really begin? Since then, I have continued to look at Mario's work, old and new, and have continued to think about the parameters of Latin America. And now, the question is more urgent, downright ontological: Does Latin America really exist?

From his home in Miami, Mario Algaze has built a considerable reputation as a photographer of Latin American subjects. Mario's camera knows that Latin America is due south of Anglo America - although there are places in New York where Anglo America is totally absent - but is there a there there?

How curious that Mario's photography, so deliberately removed from the overdetermined political life of the region he photographs, forces me to confront the region's political life, its very existence as a political entity. Indeed, Mario's photos are a corrective to the truculence of photojournalism. He shows no guerrillas, no graveyards of the disappeared, no menacing soldiers, no grieving mothers, no long-suffering peasants, no degraded urban working class. His photos can only be taken during peace, even if it's the temporary peace a photographer and his subject can impose on a war zone. And his subjects are neither the privileged nor the oppressed. They are working people who reap, modestly and often against great odds, the benefit of their work. Their nobility comes not from endurance but from achievement. Their satisfaction springs from knowing, with great certainty, who they are.

And there is no better place from which to contemplate Latin America than Miami: A US. city where English is often a second - or totally ignored - language; the interface of the Latin and Anglo worlds, where Cuban Americans, exiled from Castro's revolution, made swinging between those two worlds a profitable necessity.

Yet it is precisely here in Miami where the ontological question suggests itself with the greatest insistence. Is this Latin America we pay so much attention to here really there or is it something that not really existing we feel obliged to invent?

For it's so vast that world to the south. So different. It's black along the coastline and Indian in the highlands and white... well, sometimes it seems that those of us whose major ancestry is European are in the region only on some kind of vacation, really. Just tourists passing through, acting piggy, as tourists often do.

Mario's photos disturb me. For they are witnesses to the vastness and diversity of a world so few of us who call ourselves Latin American know like he does. Until we come here, up north, to Anglo America. And we try to make sense of one another in a land that makes little sense to any of us. And, yes, we succeed insofar as we all speek the same formal language, but even then the accents and tones are different. I look at Mario's photos and I

think, no wonder: how can anyone who comes from this lush wetland understand someone who hails from that barren plateau?: how can that Indian relate to that African?: how can the memory of a memory of Europe connect with a different memory of that same memory? We are lost, we Latin Americans, except that we don't know it until we are really lost. Up here.

Now, I don't know what it's like to see Mario's photos or Latin America *in* Latin America. For I am a Latin American who lives - has lived most of his life - in Anglo America. And so is Mario.

Like Mario I have been looking for Latin Amerika in its arts, its tastes, its taste for life, building on memory and on the life we lead within our own, peculiar Latin American culture up here in *el norte*. Ours is always a multiple perspective. We can see North America with Latin eyes. Latin America with *americano* eyes; as family members and outsiders at the same time, detached from our attachment, attached to our detached, ironic, longing point of view.

Sometimes, for all your fluent Spanish, all jour Latin jazz, you can find yourself in a foreign world, where *you* are the gringo in blue jeans talking to your fellow Cuban American in English because it's the only language that makes sense to both of you right then. It's at that point that an American, a real American, will enter the scene for a moment - a friend, a colleague, a perfect stranger. Afterward, you look at each other and shrug: how strange these gringos are. And that's when you know why you're in Latin America. To drive down a road flanked with mirrors, looking for yourself in the parallel walls of multiple reflections. It's good to find someone else on that road. You pass each other. You drag. You cruise side by side.

And, yes, it's there, in the photos, that connection, that lost world. As if Atlantis.

I first met Mario very briefly in New York, but that didn't count, really. Still, for the record: The INTAR Gallery had asked me to write the program notes for a one-man show by a Cuban-American photographer who shot portraits of Latin American artists. Against my protests that I knew nothing about photo criticism, the curator insisted that I was right for the job because I knew something about the subjekt matter - later I learned that it was a trend in the art world to cast noncritics into the sea of art criticism. What struck me right away about Mario Algaze's portraits was their rightness. I called my notes "Cada uno en su lugar". Each one in his/her place. The famous Cuban writer and ethnographer Lydia Cabrera, for example, was shot surrounded by her Afro-Cuban icons, many of her own making. Mario knew enough about his subject and his subject's subject to frame the frail old lady by objects that, in the African-based traditions she had studied and interpretet, meant power. It was a portrait of a warrior. A subtle warrior and a subtle portrait.

These portraits, like other Algaze photos I was shown then and have seen since, were quite serene. They asked for contemplation, for attention to detail and nuance. Not just aesthetic contemplation - awareness of composition, texture and, most of all, light - but also cultural contemplation. These photos said something. They captured an attitude and had an attitude

of their own. That attitude felt comfortable close to mine, except far more deliberate, less restless. Eventually, I startet to see the restlessness locked inside these clear, elegant compositions. And then I really met Mario.

It was here in Miami. It was the 80s. *Miami Vice.* The writers - and there were many and distinguished - who came to ponder on the city during that glittering decade all agreed that even when it was not in evidence this town was fueled by cocaine. Like the razors that cut the rock into powder, Miami had an edge, was on edge. Fast talking and fast driving (I've seen a Porsche crash head on to a Mercedes, both at high speeds, as if staged for a movie, except that it was real and scary). Mercurial moods that God forbid any guns were around when they shiftet. A general impatience in this otherwise languid tropical city. And here was this photographer who rapidfired Cuban Americanese and gesticulated wildly in Calle Ocho sign language, possessed by, as a common friend would later tell me, with "a patience threshold of minus one." Uh oh, I thought, another one.

I was dead wrong. Mario was so straight that if he drank half a beer (his limit) he claimed to be hangover the next day. Anything else was anathema. A sixties' veteran, he told tall tales of psychedelic overload, but I never fully believed him. He was simply tripping on his own metabolism, which also kept him bone-skinny no matter how many *palomilla* steaks he devoured at Little Havana eateries. Mario was speed itself, camera film speed, camera shutter speed. And he was good.

We startet to work together. Magazine assignments where he was my photographer. Photo essays where I was his writer. We worked well together for we had a common vocabulary. I mean this in the most vulgar sense, not that we had a common artistic vocabulary, although there was certainly some of that. We simply spoke the same language(s). Spanish, Havana variant circa late 1950s. English, US. variant circa late 1960s. Spanglish, Cuban American variant circa 1980s. No need to explain anything.

But in the end the assignments became less satisfying. Mario was overseen by some photo editor, I by some article editor. And neither of them spoke our vocabulary, vulgar, artistic or anything. What we really wanted is to be told: go out, get a story, get pictures. What we really wanted is to be let loose together. It seldom happened.

Mario in particular has no stomach for the demands of commercial photography. It's no secret that he's headstrong, willful, contrary, difficult. On one assignment we did together he shot roll after roll of film because that's what was moved to do: his editor freaked. Most importantly, he's not trendy, disdains the whole phenomenon. On another assignment, supposedly to capture the spirit of the real Miami one never sees in the magazines, he balked at having to photograph only trendoids "with no less than three earrings on each ear", instead of the subjects he suggested.

For, indeed, Mario does not belong in the trendy magazines. He belongs only in two places: the fine arts galleries and the street. If he couldn't make his living as an artist, he would have to move down to some Latin American city and roam the streets photographing

the country folk who want a souvenir from their trip to the capital and only can afford a peso or two. Fortunately, the fine arts have been good to Mario. And he lives in Miami.

. . .

"I owe my photographic career to a ride and a joint", says Mario Algaze, in a psychedelic reverie. In 1969 he was hitchhiking around Miami when a Porsche pulled up and its driver, high as a kite, invited him to ride all the way to a Woodstock-like rock festival in Louisiana. "Bring some girlfriends," his new friend said, dispelling Mario's concern that this was a gay pickup, and Mario obliged by asking two young ladies to join their host and his own lady friend, on this late 60s rock trek. With a twist: "He bought a mobile home so we could travel in style. No tents for us."

"This man was quite knowledgeable about photography", Mario recalls. "His name was Dave Laurence and he had invented an optical computer for the Kodak company." Interestingly, Laurence had spent time as a photographer at the old Havana Hilton, serving as Mario's first link to his Latin American photography. "He handed me a camera and he taught me how to make a living as a photographer," remembers a grateful Mario. Still, there was an element missing: "What he didn't teach me was the art behind the camera."

That would come later. Mario dove into the world of rock'n'roll photography. "I went to shoot the music scene of the 70s. The Stones, Zappa, Dave Mason." Mario worked for the rock magazine *Zoo World* and did album covers for record companies. But this world, classically full of sex, drugs and rock'n'roll, let him unsatisfied.

"In 1974 I went to Latin America to look for my roots. To Mexico because it was the closest and the cheapest." Mario's father lived there and the work from that period and a gold Patek Philippe watch are what's left of him in Mario's possession. By 1976 he was no longer interested in going anywhere else but Latin America, although in 1979 Mario opened a photo gallery in Miami that occupied him for two years. In 1980 he returned to Latin America and, in a way, he never came back.

. . .

"The Miami International Airport is like a McDonald's to me", says Mario. "I feel like a kid when I look at all those departures, all those wonderful places you can leave for every five minutes. Pick and choose. What are you going to have today? A quarter pounder? That would be a trip all the way to the tip of South America. Or maybe just a plain cheeseburger? A trip to the Caribbean or Mexico."

Indeed, the airport, which is the key to Miami being the most central city in Latin America even though it's in the United States, is also the key to how an artist like Mario can be a working Latin American photographer even though he lives in the United States. Even more so.

8

"There are very few connections between neighboring countries in Latin America. To get, say, from Quito to La Paz, two cities I have photographed extensively, you have to take three planes. While from Miami you can get to either one of them quickly and frequently and directly."

It's a Latin American commonplace that we often know more about culture in Europe or the United States than about what is happening right across our border. Often, we flagellate ourselves for this ignorance, blaming the kind of self-loathing that can spring in Third World people who aspire to First World privilege. But Mario's explanation is much simpler and assigns no guilt. We simply can't get from A to B. So we come up here, to C. Or we stay home.

"The Latin American photographer shoots his own surroundings," explains Mario. "I have the advantage that from Miami I can shoot everything." And he looks around his home to the boxes and boxes of prints. "If that airport did not exist, this body of photographic work would not exist either."

. . .

"I never want to drop the vision, the ultimate goal: to be recognized as one of the great Latin American photographers. Who lives in Miami for political reasons..."

He trails off, there is something else, he knows it, I know it, it haunts us. "Or because I'm chickenshit and don't move to Latin America." That's it, isn't it? The Latino conundrum. If we are Americans, in the US. sense, why do we constantly look south? And if we are Latin Americans, why don't we live there?

"...except that it's hard to produce a neat photography, of good quality", he finishes the thought. "One needs the resources of the First World."

So here is Mario. Eating his cake and having it too. Being a Latin American photographer who can avail himself of a US airport and US photo laboratories and US photographic material. In the best of both worlds. And paying a price. Because if your artistic heart belongs *down there*, what kind of heart is left to belong *up here*. How could you even fall in love? Mario Algaze lives alone.

. . .

In many ways he does not belong *up here*. At least not in this up here. "I have felt there is more affinity for the type of photography I do in Europe than in the US. Europeans are more aware of South America than North Americans. Europeans are more...explorers."

But perhaps not even European explorers could understand, never mind enjoy, "the great Latin american disorder, not even the Third or the Fourth World, the *Eighth* World." And Mario points to a photo taken in the Dominican Republic he understatedly calls "A Painted

Palm". Yes, there is a palm tree in it and the bottom of its trunk has been typically painted white. But there is also a mayhem of signs, a cornucopia of visual litter, a real mess. The great Latin American disorder. The *Eighth* World.

"To Europeans Latin Americans are a man with a guitar", says a character in Gabriel García Márquez's *No One Writes the Colonel*,
 "They don't understand the problem." – *"No entienden el problema"*

We understand *el problema*, those of us who were born and raised *down there* and who insistently continue to commune with the region. And we understand how difficult it is to make sense of the semiotic jungle that is our Latin American disorder, how difficult to bring our Eighth World up to the Seventh, Sixth, Fifth, Fourth, Third, Second, First!

¡Pero qué rico!, as Mario himself would say in that sublanguage we both speak. How rich, how delicious. Is there anything sweeter than creole life? I mean *criollo*, not the narrow racial sense that the word "Creole" often has in English. I mean the people of the Americas, of whatever race, whose culture, which is where the races mix with more enthusiastic promiscuity than in the blood, is a fusion of African, Native American and European - seasoned with a few other exotic ingredients. Life in Latin America can be as brutal as the headlines about the region or the infernal poetry of photojournalism. But there's another life of everyday pleasures and accomplishments and satisfactions.

Curiously, this quality of life comes from something we don't often associate with the region: security. Though Latin American life, like life everywhere else, is rapidly slouching toward modernity, its predominant note is still traditional. A tradition-oriented society affords a certainty about family and relationships absent from the more modernized world. One is sheltered - perhaps, overprotected, even fenced-in - but definitely sheltered. In such a setting the soul blossoms. If Latin Americans have a "romantic" reputation, it's because theirs (ours) is a culture where one can devote oneself to relationships, to loving and being loved. Or, to borrow a phrase from Spanish filmmaker Pedro Almodóvar, one can devote oneself to the cultivation of one's personality.

It's a pleasure-oriented culture, where the aesthetic standards of everyday life are quite high. This may sound paradoxical given the degree of modern tackiness one can see in Latin America, as in all of the Third World, the sad aesthetic legacy of economic imperialism and underdevelopment. But beyond or outside that ill-digested modernity there is a nearly instinctive preoccupation with taste, look, feel.

Many of Mario's photographs revel in the art that most imposes a sense of style on Latin American life: architecture. Stairways, columns, porches, balconies, roofs, doorways, arches, walls. And windows. Windows blackened with the darkness of interiors, promising mystery of nothingness. Windows flooding the scene with light.

The Latin American aesthetic inclination transcends questions of class and race. Often the truly privileged, authentic, aesthetic moments will belong to the poor, or to the very modes-

tly prosperous, the working small-businessmen/craftsmen Mario likes to photograph: the barbers, carpenters, farmers, street vendors that form the rich, deep *criollo* fabric of Latin American life.

An admirer of Latin American primitivist art - which is anything but primitive - Mario looks his subject in the eye, fills the frame with every necessary item of information, and lets the image settle into the photograph, feel at home in it, revel in being so lovingly framed and reproduced. These images are the right ones. They have reached their plenitude.
But they have been changing.

. . .

"Before, my photography was more informative", says Mario, contemplating his latest work. "Now, it's, what can I tell you?, a play of light." From the beginning natural light has been Mario's true discipline. He would rise early to catch the magic light, as photographers call it, to see the world reborn. It's a beauty, that first morning light of a Latin American city coming to life. The street vendors set up their stalls, children stride to school, housewives start the day's food shopping, workers light their first cigarettes. Everything smells fresh baked, fresh cooked, fresh born; everything has a glow.

Yet, in the photographs, all is not sweetness. Light can conjure ghostlike figures, or it can draw hard geometric shapes, or it can disappear. And, yes, more and more the play of light itself has become his subject. Could that be the answer to my ontological question?

Many years ago, I set out to find Latin America. Unlike Mario I did not pack a camera and drive to the airport to board a plane headed south. I went to a university and signed up for graduate courses. In a way, I went to the true home of a Latin American master both Mario and I admire, Borges. I went to the library.

And there I found Latin American literature, and, of course, I found Borges - and Cortazar, his heir, and Carpentier, his contemporary, and Rulfo, Fuentes, Vargas Llosa, Cabrera Infante, Paz, Lezama. It was in Borges himself that I found the answer to the question of Latin America's existence, though it would take almost three decades and the help of Mario's photography to understand it. In Borges, that great librarian, I found the labyrinth.

At first, I thought it was a classical trope, filtered through modernism (Joyce). Then - it was the 60s when I found it - I thought it was a mind bender of nearly mystical reach. Or a literary joke: the library as labyrinth (Borges and Eco), the text as labyrinth: a semiotics for semiotics' sake. But no. One journey through Mario's work from the 70s to the present and there it is. The labyrinth is Latin America. Latin America is the labyrinth. A labyrinth as play of light.

Those street corners: streets meeting, parting, "resounding" as in a famous Octavio Paz poem. Colonnades. Cafe corners and tables and doors, witnesses to the weavings of

comings and goings that are present in absence. Stairs. Rooms open to mirrors, closed to the world. Signs pell-mell. Or barrenness, the ultimate labyrinth (Borges again, always).

The human figure may be there or not, but the labyrinth is never inhuman, though it may be difficult. *No es fácil.* It ain't easy. Not easy to live in streets that meet and part with a dreamlike insistence. Not easy to be haunted by columns. Not easy to come and go. Not easy to suffer the sight of the majestic volcano or the desolate emptiness. Not easy to read all the signs, all the signs, all the signs at once.

Not easy but necessary. That's what drives Mario to Latin America. That's what drove me to the library. Hunger for the labyrinth. Here in this world without labyrinth, where everything is clearly marked, as in supermarket aisles, where there is no Eighth World disorder, one pines for that dizzying density. Once, when Mario was feeling testy about living in the US. and angry with himself for being, as he says, too chickenshit to move down there, he told me: "I want to breathe the fumes of cars before catalytic converters." Could anyone be mad enough to feel addicted to such cancerous airs? Of course, one could, not just because it is no different than a cigarette addiction but because I too had felt that pain in my lungs. I wanted to breathe underdevelopment.

The labyrinth of underdevelopment, cancerous airs and all, where nothing makes sense because everything makes sense at once. And where, curiously, happily, one feels good there, in the dreamlike intersections, through the haunted colonnades, in the burning plain, under the volcano, surrounded by signs.

Is there a place *here* that is like *there*? Does Latin America really exist in Mario's adopted home city? I used to think not. That his life here, like mine, was an accommodation to politics and economics, a cop-out of sorts, a necessary cowardice. But now I know there is a there here. A true labyrinth. Of intersections, comings and goings, escapes and claustrophobia, overwhelming experiences and endless solitude, Eighth World disorder, and signs, signs, signs.

It is the place Mario has never visited without his camera though he has never photographed it. Not the flip American pop metaphor he invented to show off his throwaway cleverness, but his true home. The place of his constant departure and inevitable, eternal return.

Enrique Fernández

Plates

1. Rio Negro
Amazonas, Brasil 1993

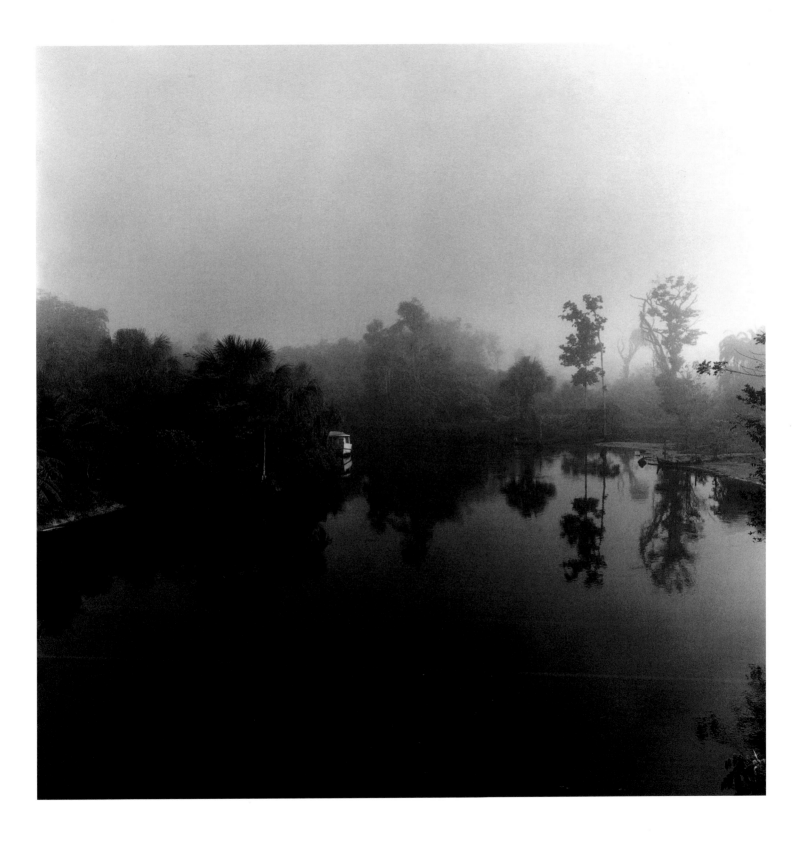

2. On the road to Irazú
Meseta Central, Costa Rica 1987

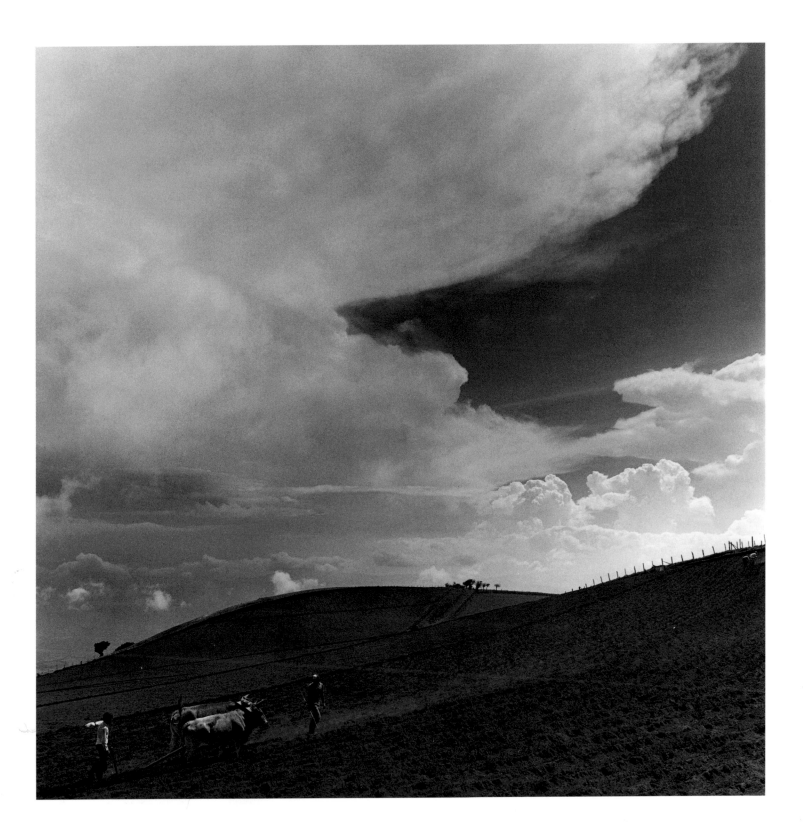

3. Cordillera Oriental
Bolivia 1989

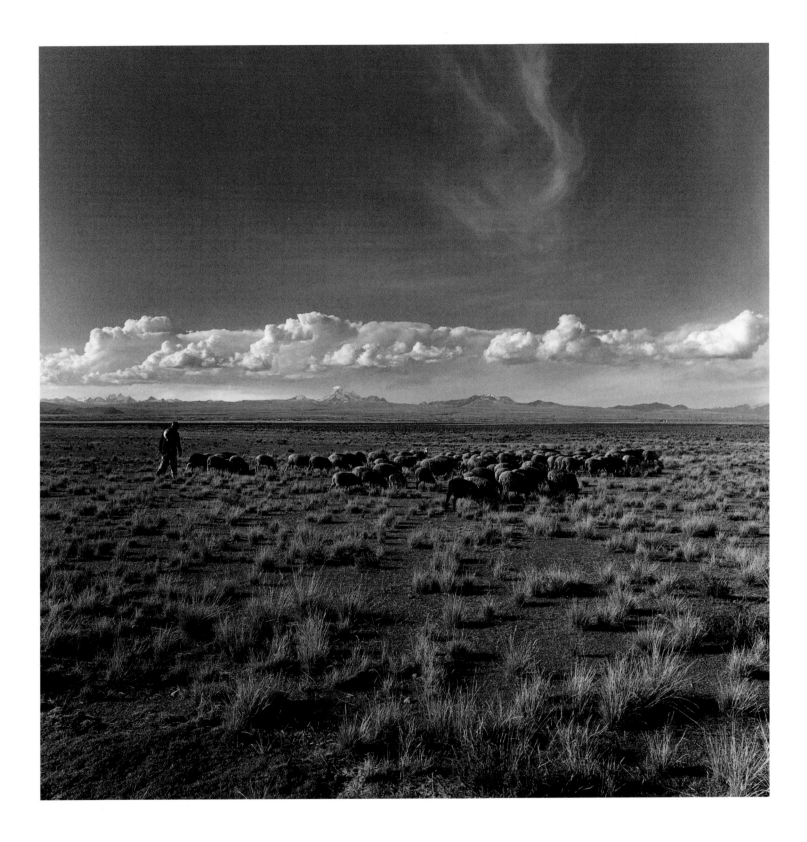

4. Lavanderas
Lago San Pablo, Ecuador 1988

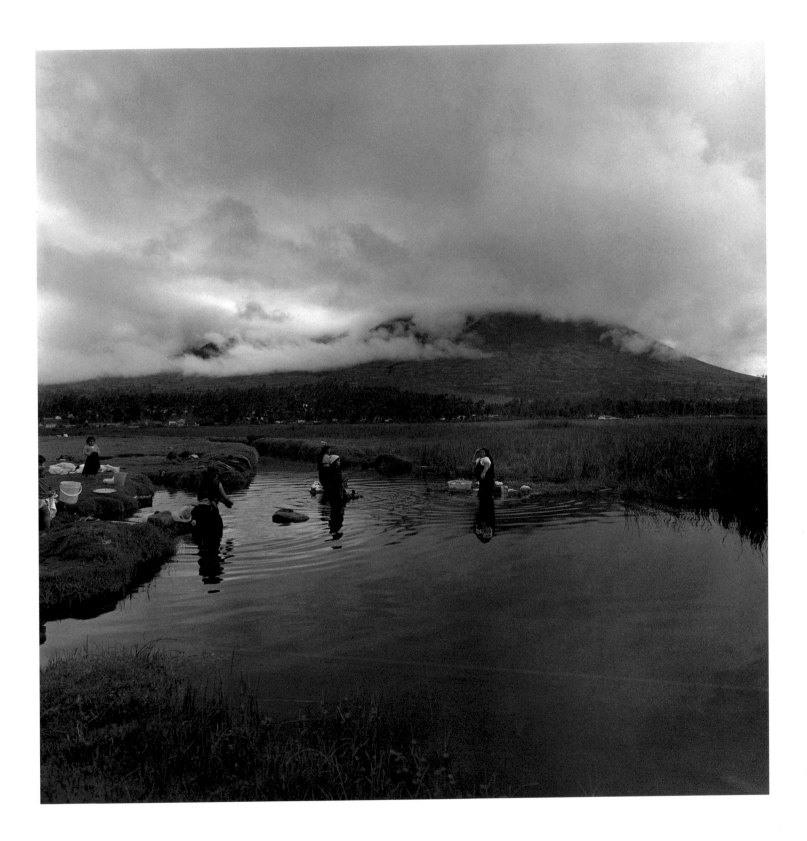

5. Pescadores
Cartagena, Colombia 1987

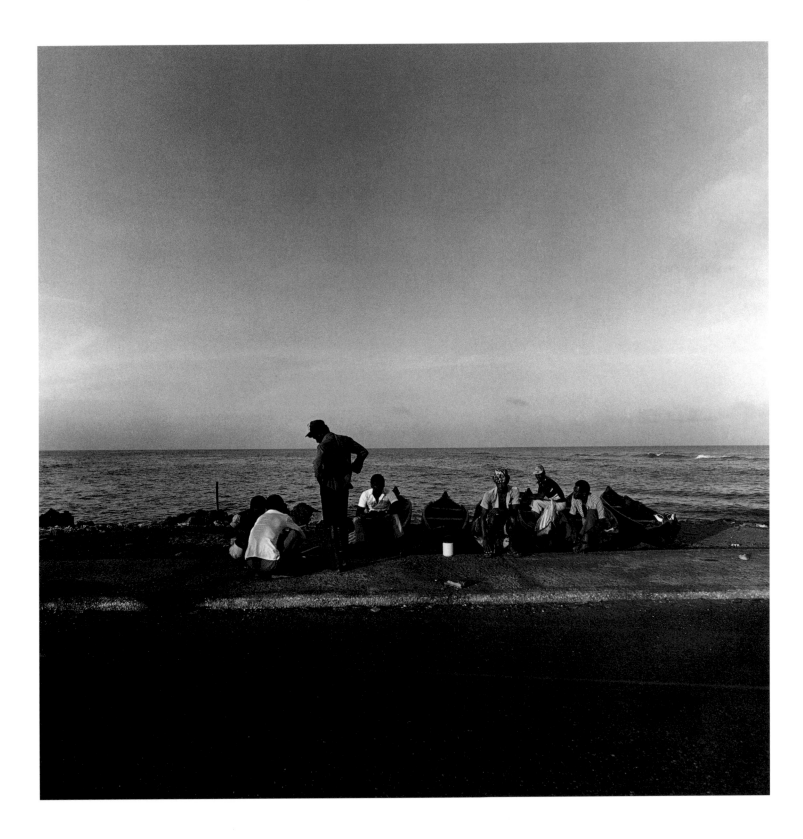

6. La danza de dos arboles
Colonia, Uruguay 1993

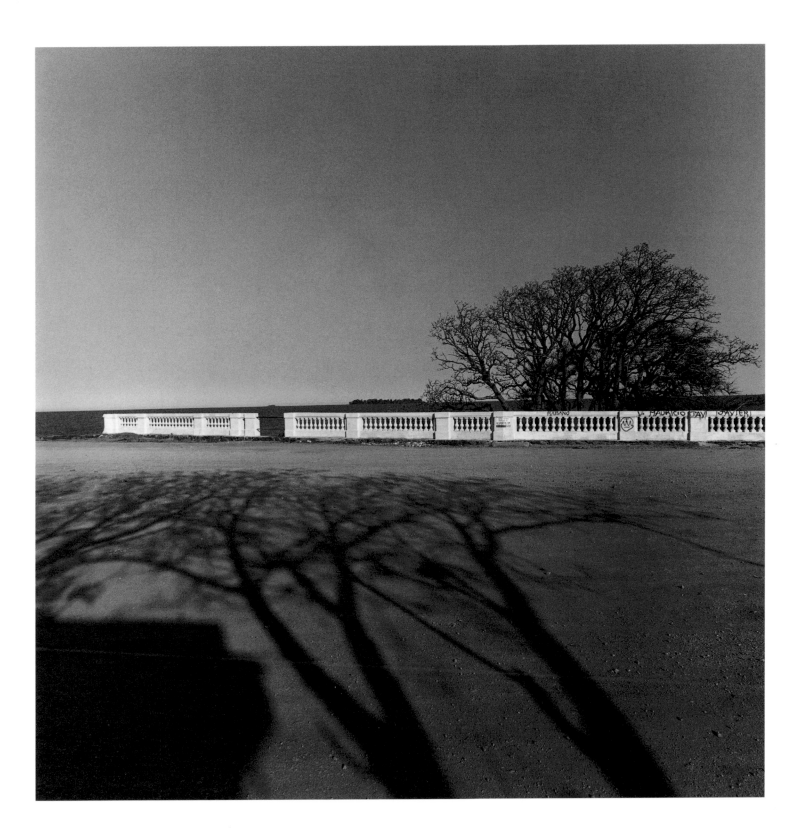

7. Cuzco
Perú 1985

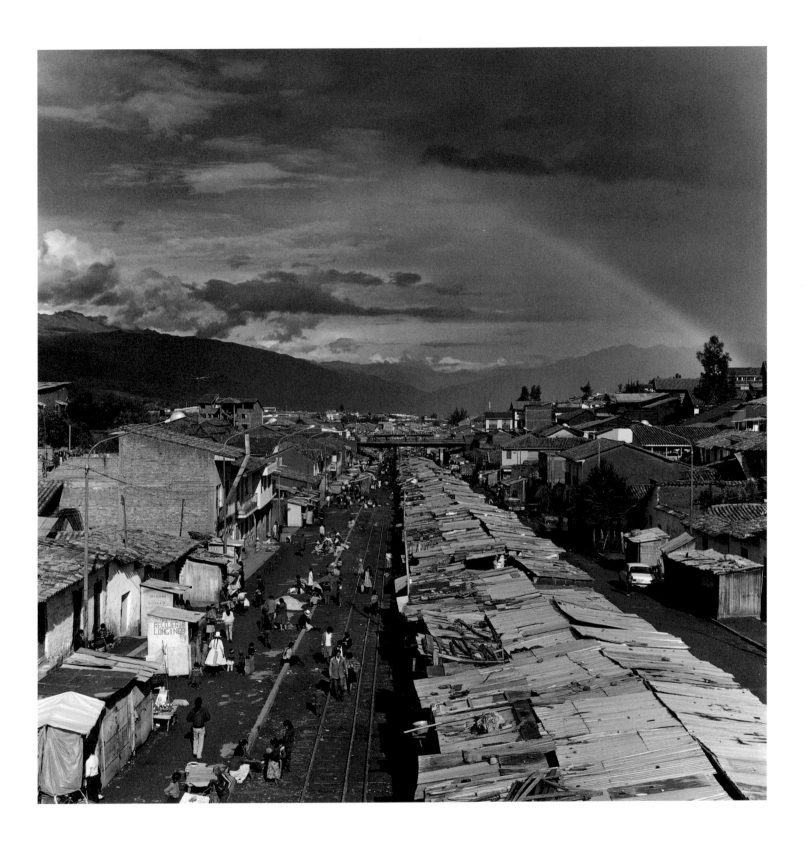

8. Hotel Zulia
Quito, Ecuador 1988

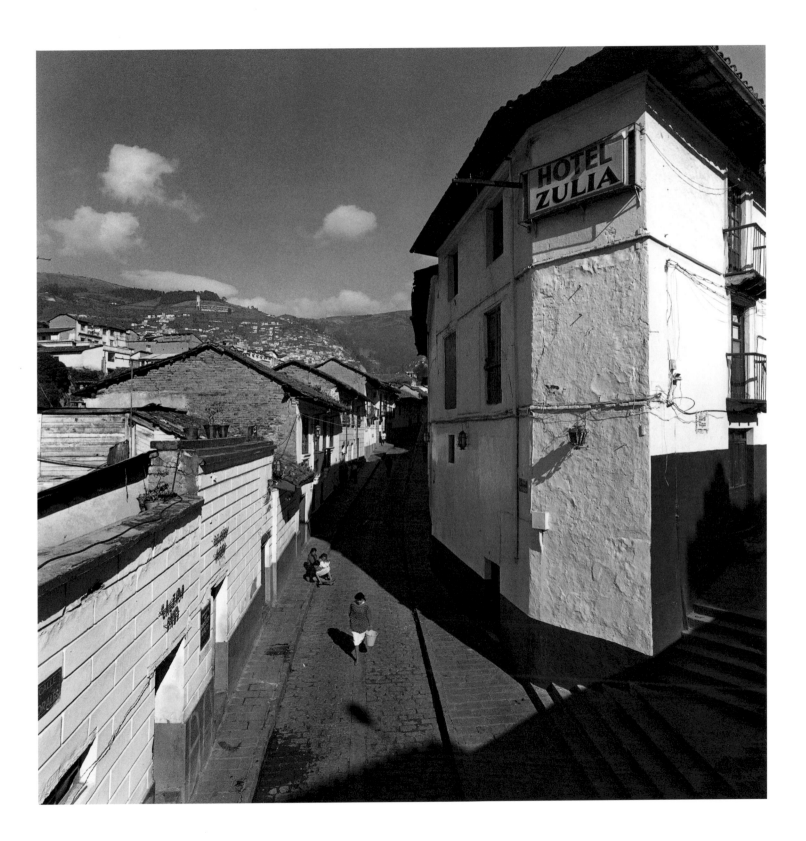

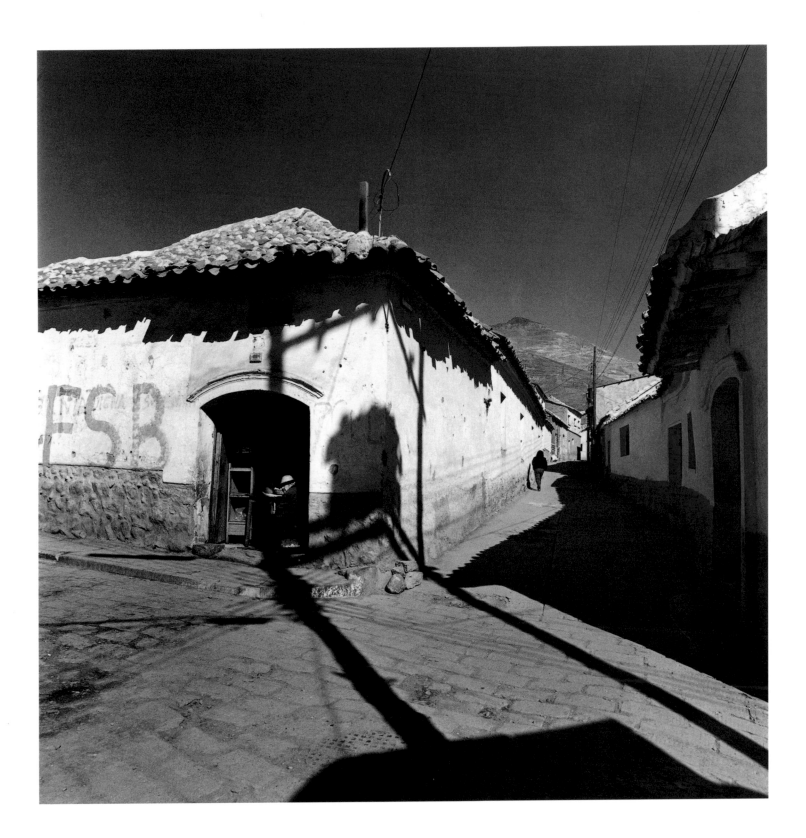

10. Se aproximan las elecciones
Panamá 1994

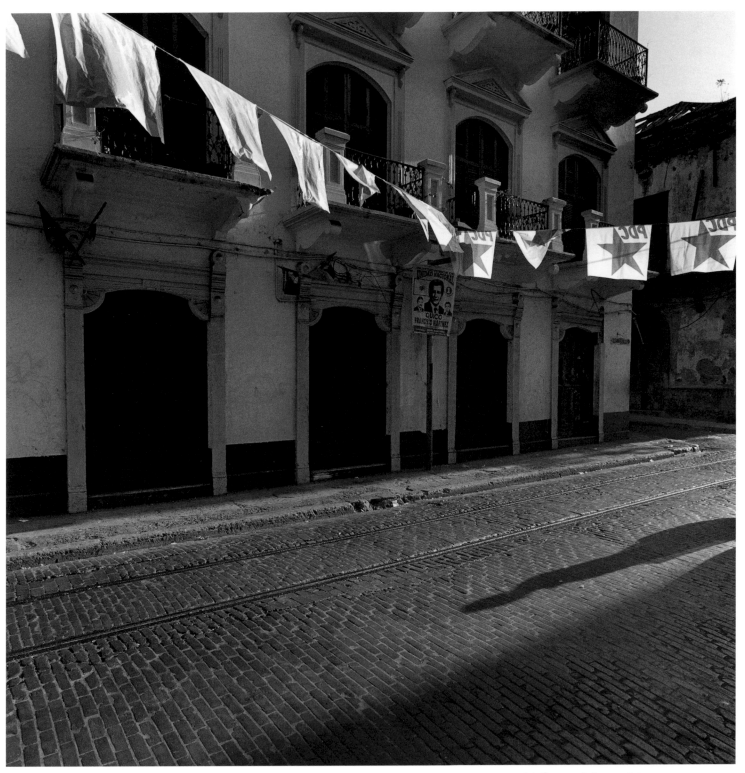

Art Center College of Design
Library
1700 Lida Street
Pasadena, Calif. 91103

11. Reflexión
Manaus, Brasil 1993

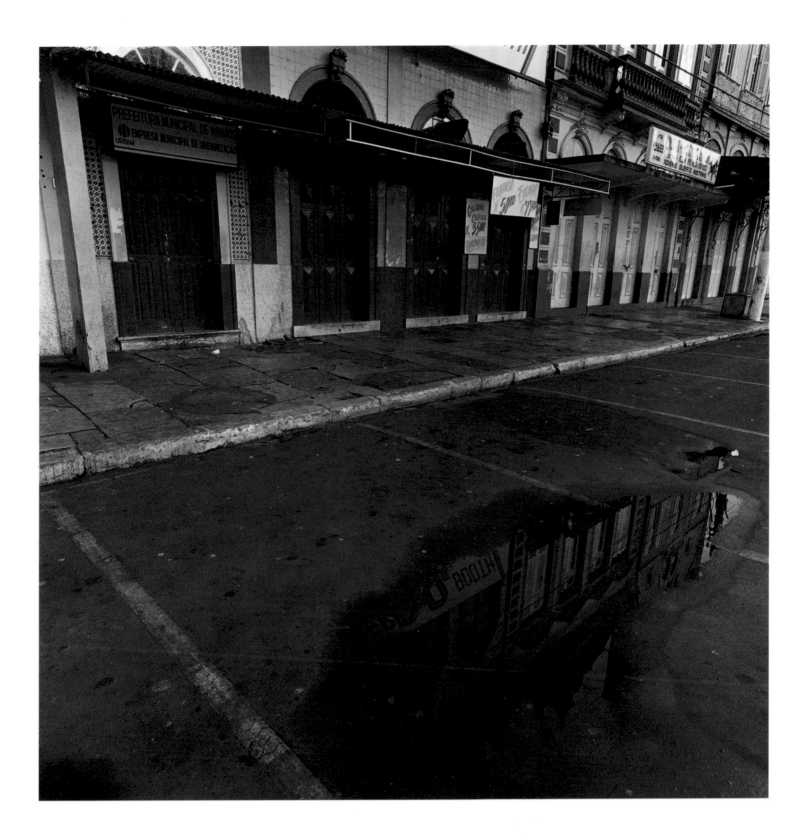

12. Prografika
Guanajuato, Mexico 1992

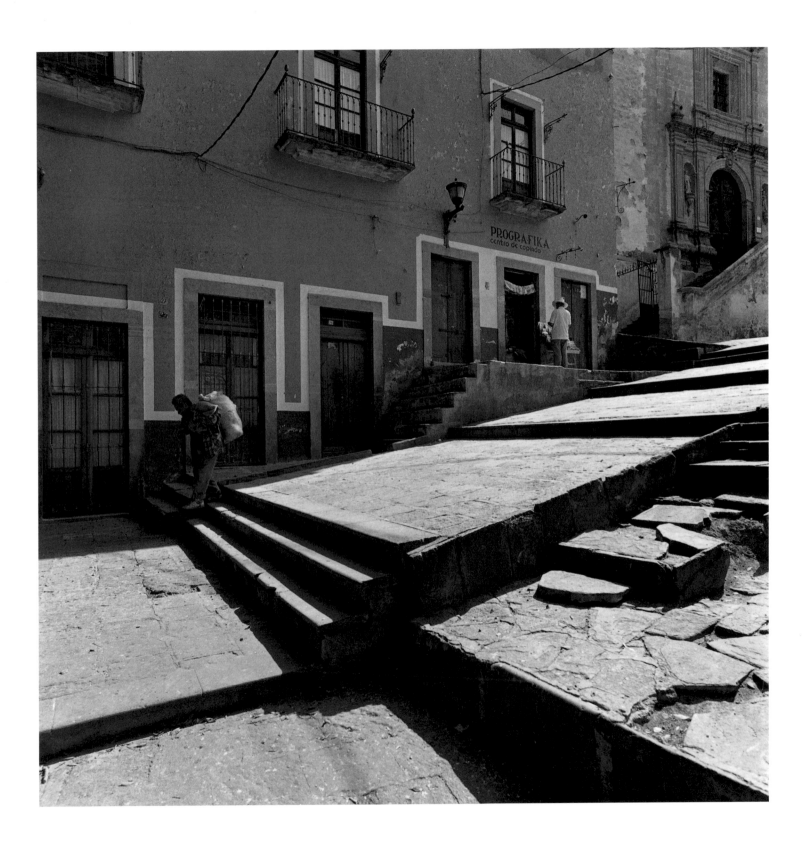

13. Desaparecidos
Buenos Aires, Argentina 1984

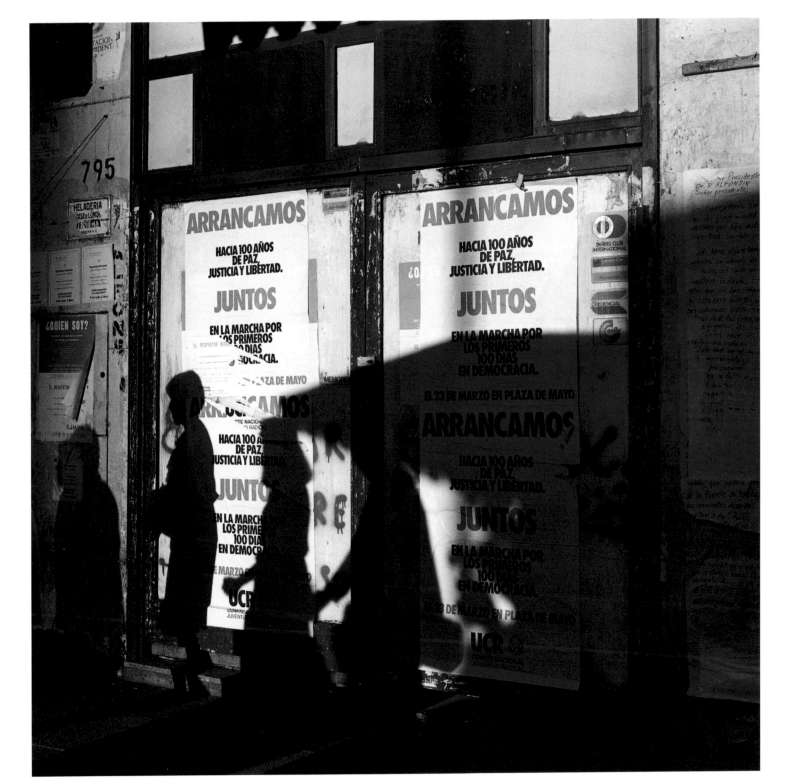

14. Carretas
Guatemala 1979

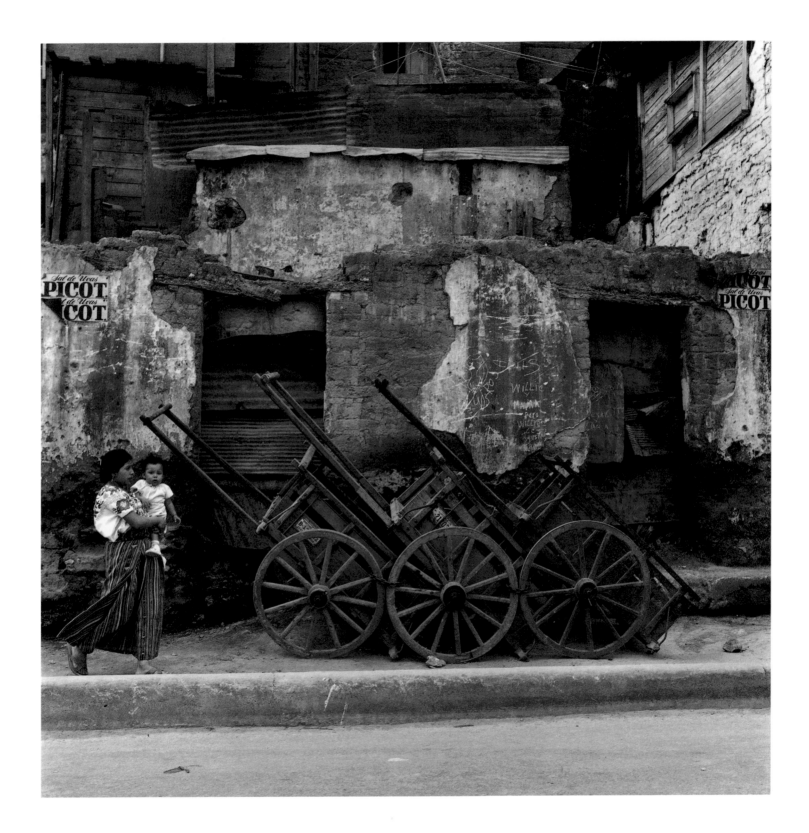

15. Convento Las Capuchinas
Antigua, Guatemala 1990

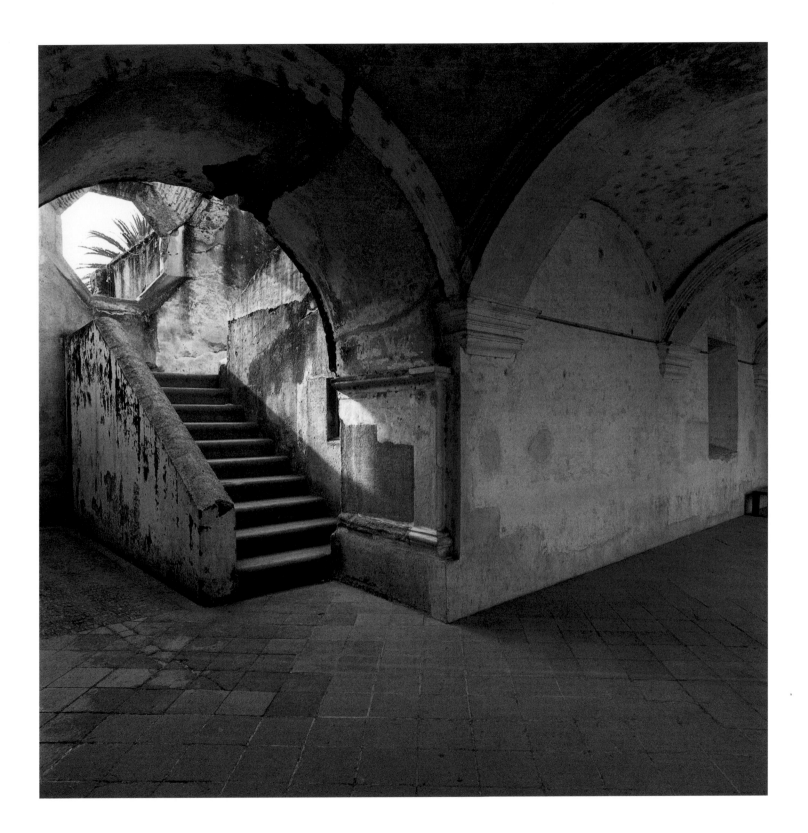

16. Carga pesada
Riobamba, Ecuador 1990

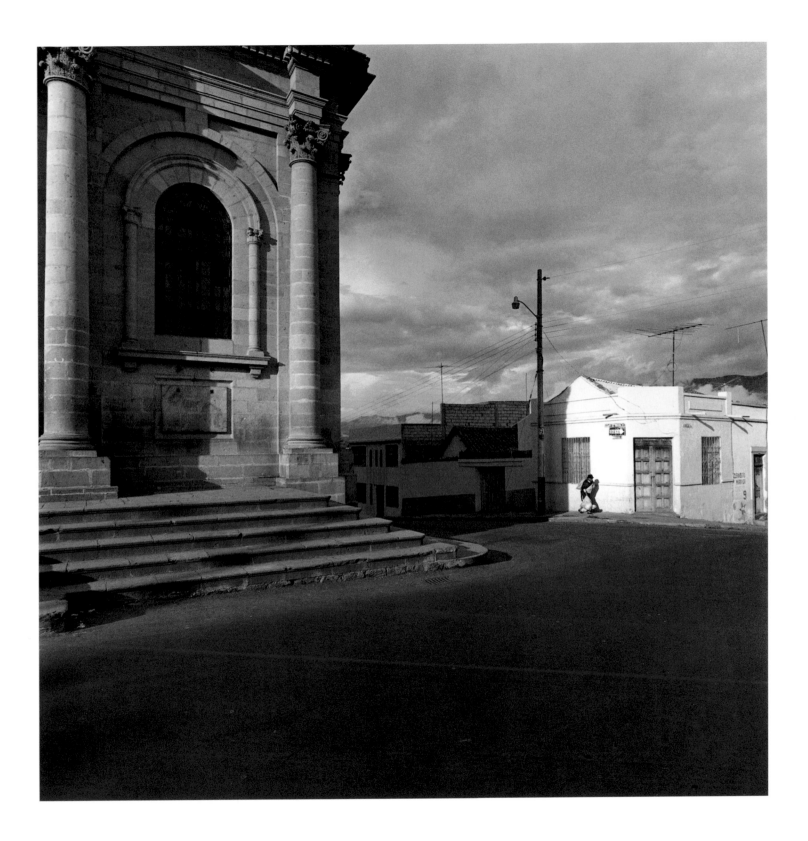

17. Cementerio de Sololá
Guatemala 1990

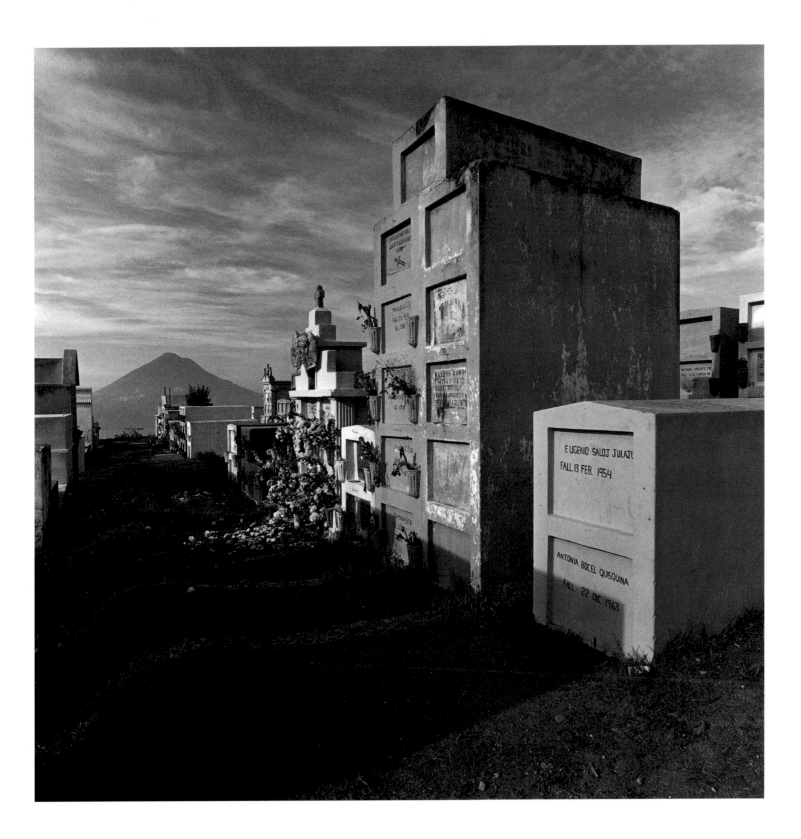

18. La Casa de San Vicente Ferrer
Quito, Ecuador 1989

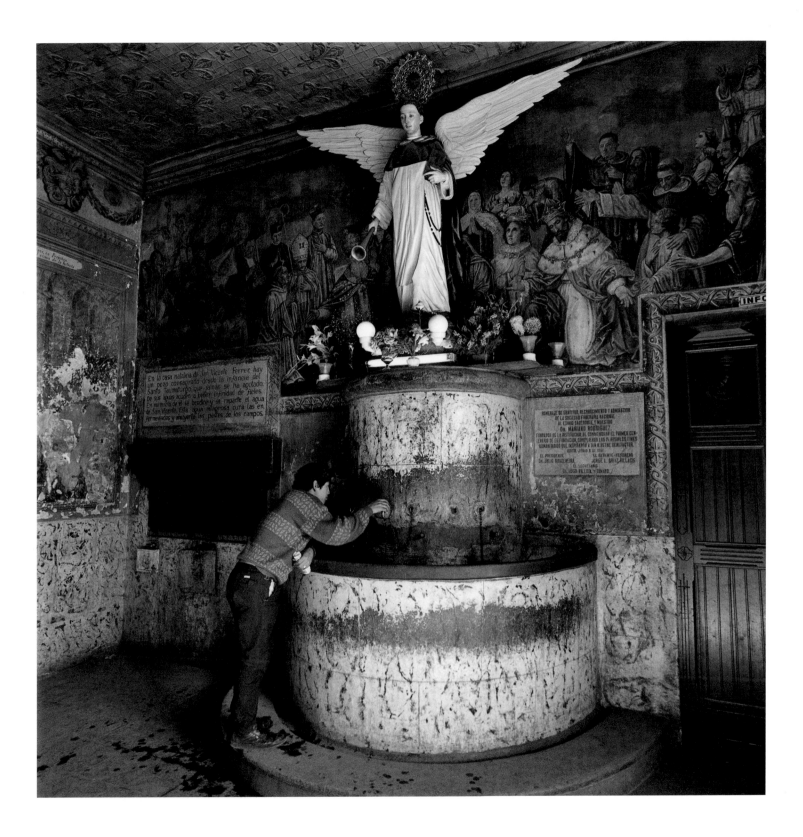

19. Baños
Cuenca, Ecuador 1990

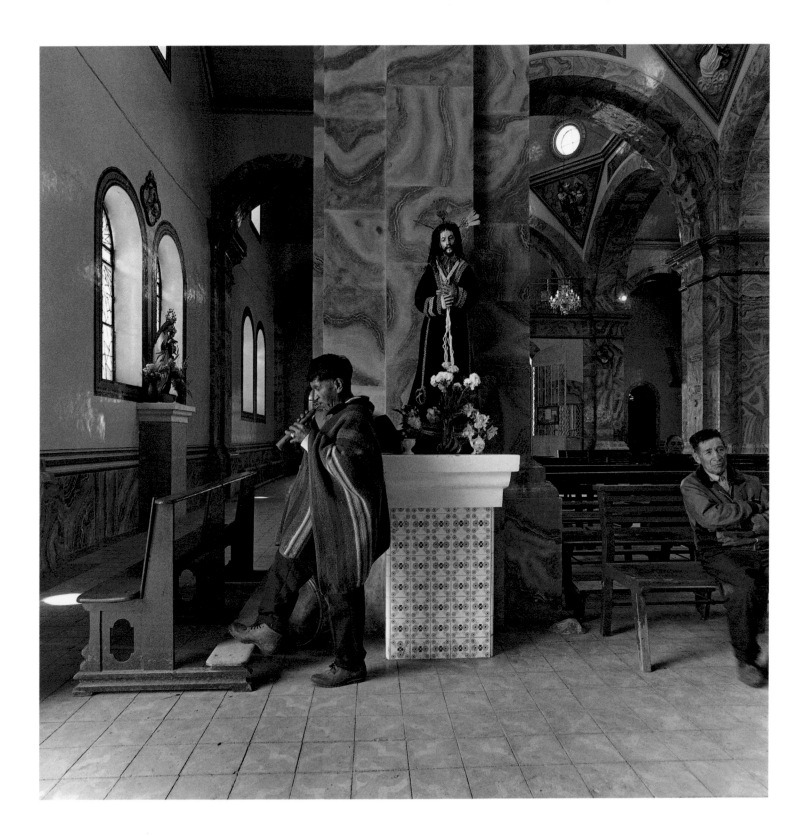

20. Curridabat
Costa Rica 1987

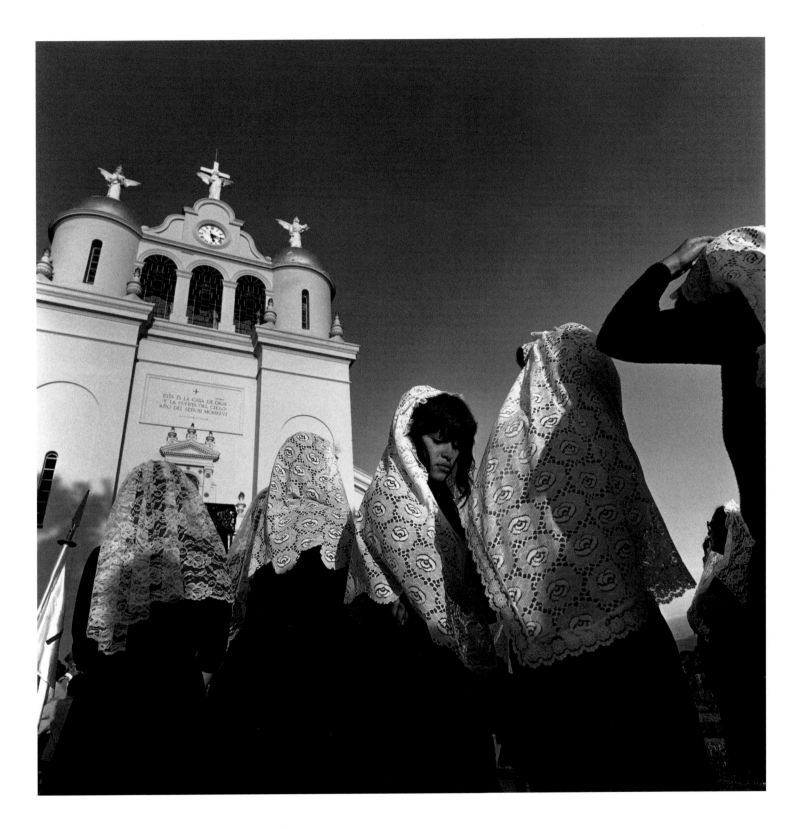

21. Cotton Candy
San Angel, Mexico 1981

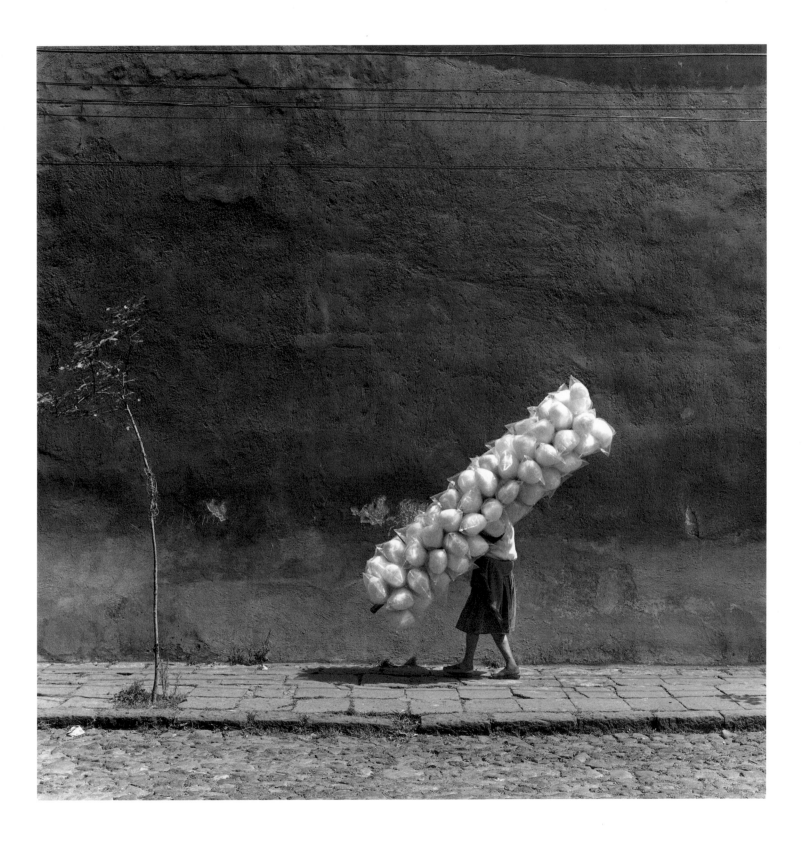

22. Paisaje urbano
Colonia, Uruguay 1993

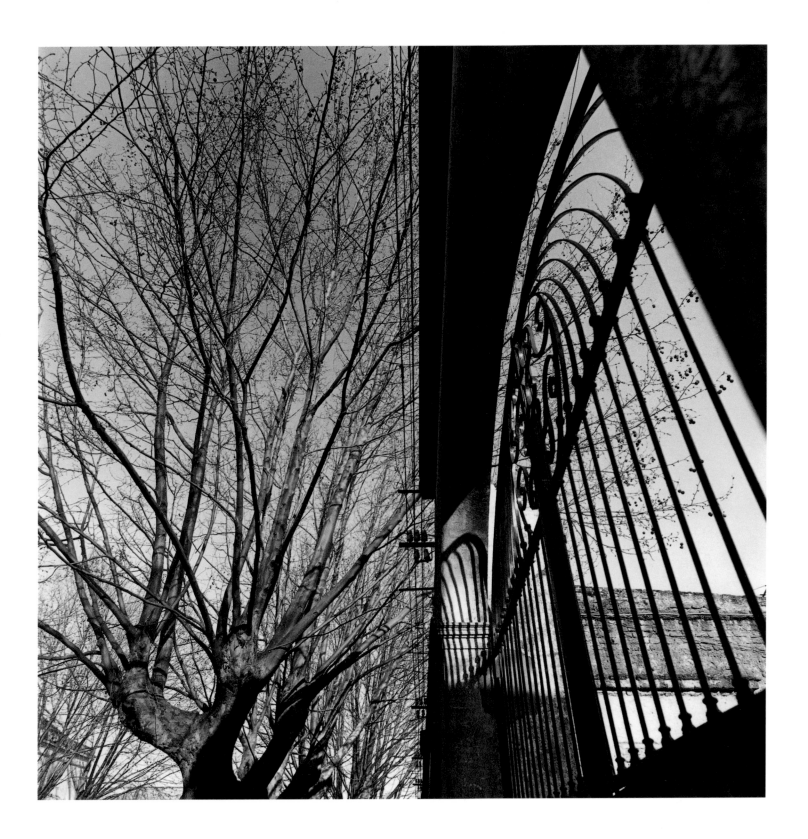

23. Rope
Otavalo, Ecuador 1988

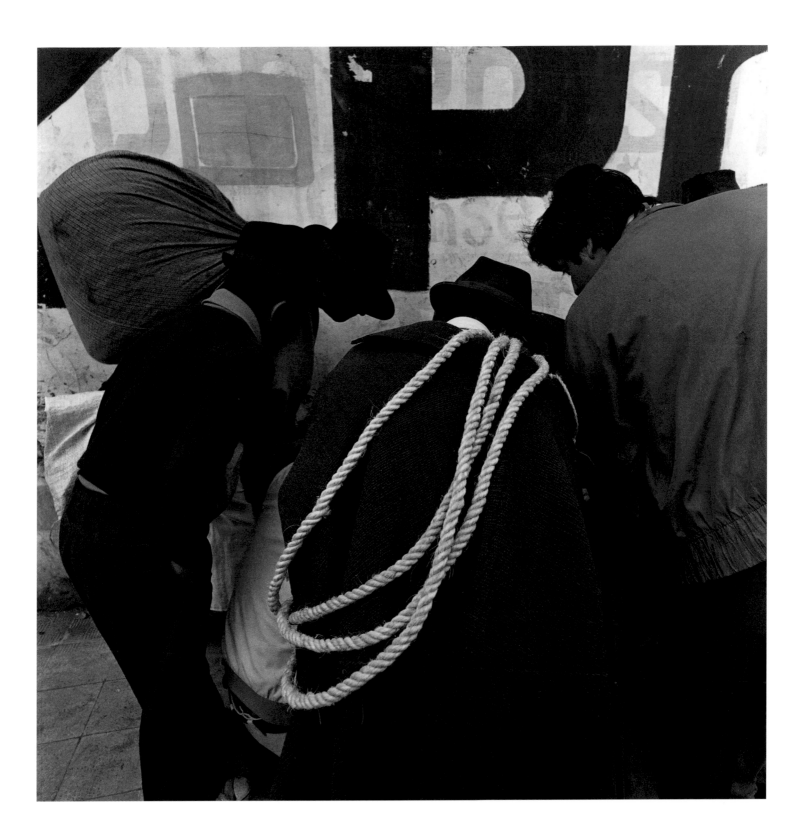

24. Torre del Reloj
Cartagena, Colombia, 1987

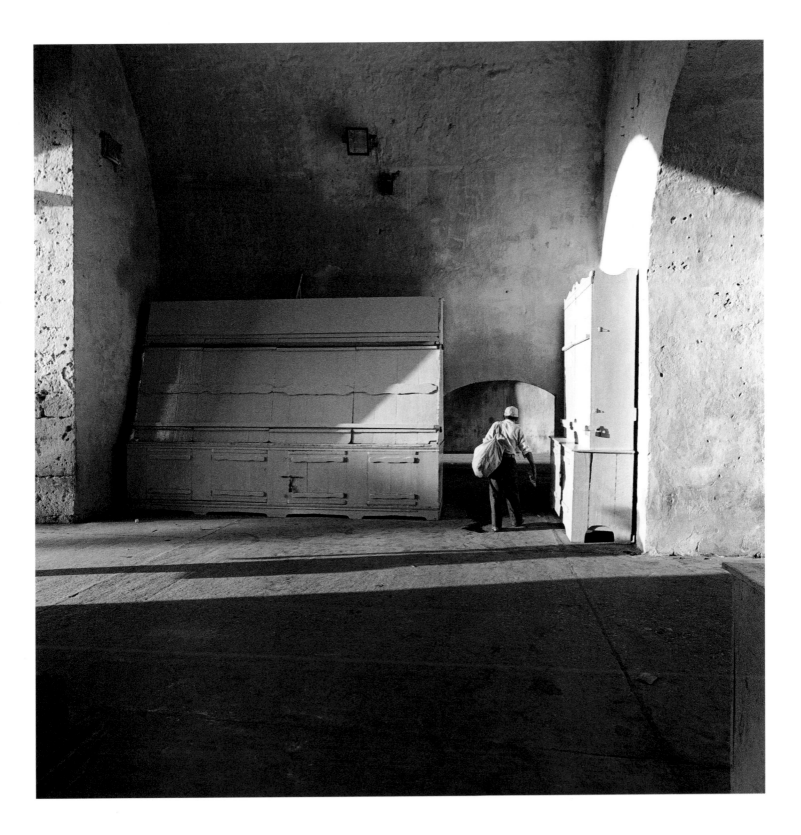

25. Bodegón de La Candelaria
Cartagena, Colombia 1987

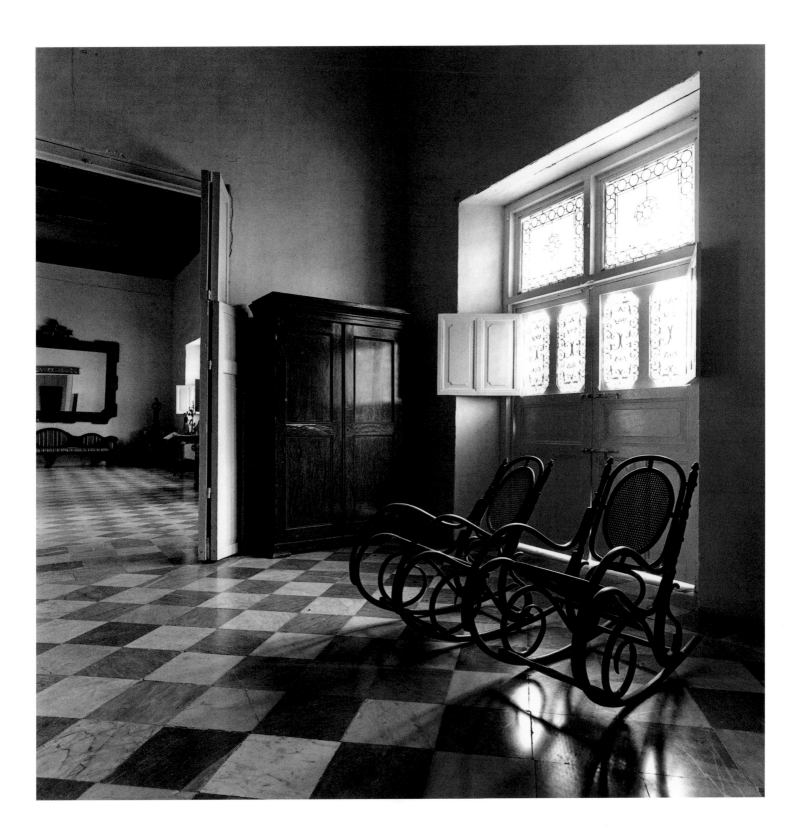

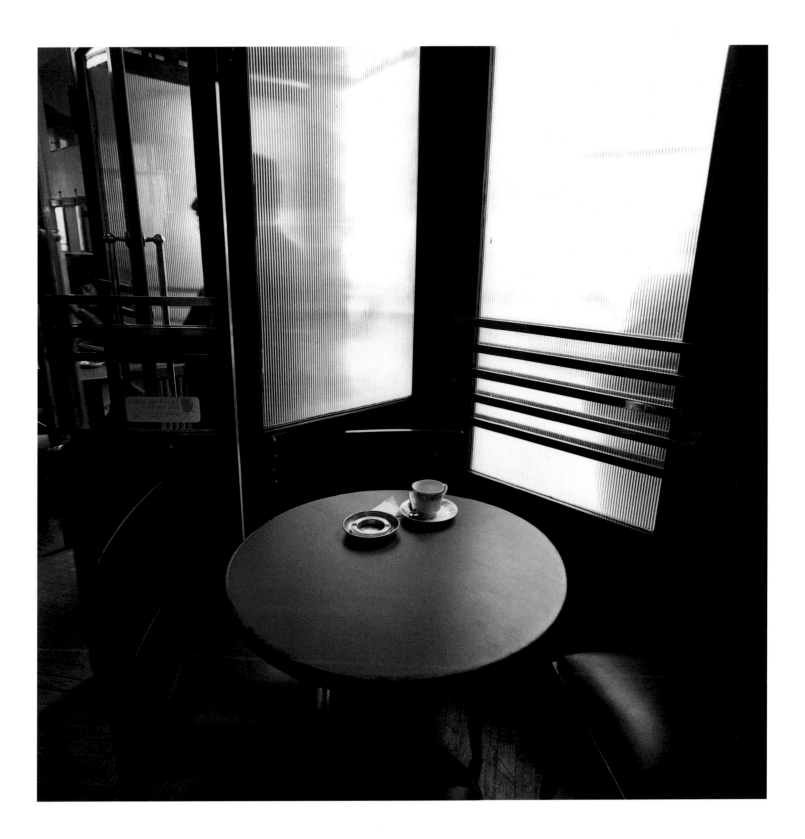

27. Cantina
Lima, Perú 1983

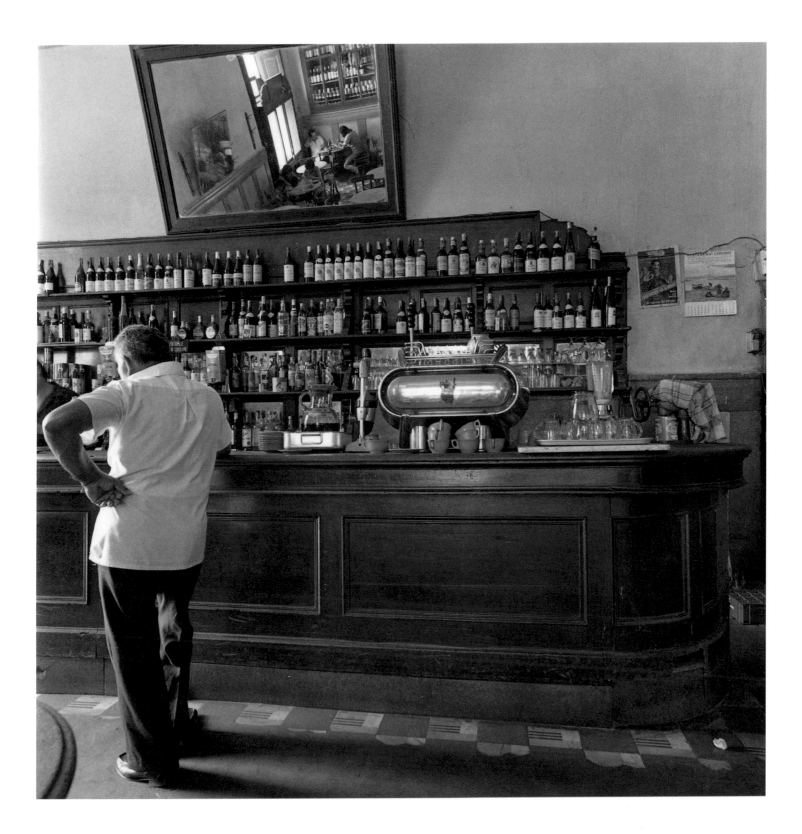

28. Espejo Barroco
Otavalo, Ecuador 1988

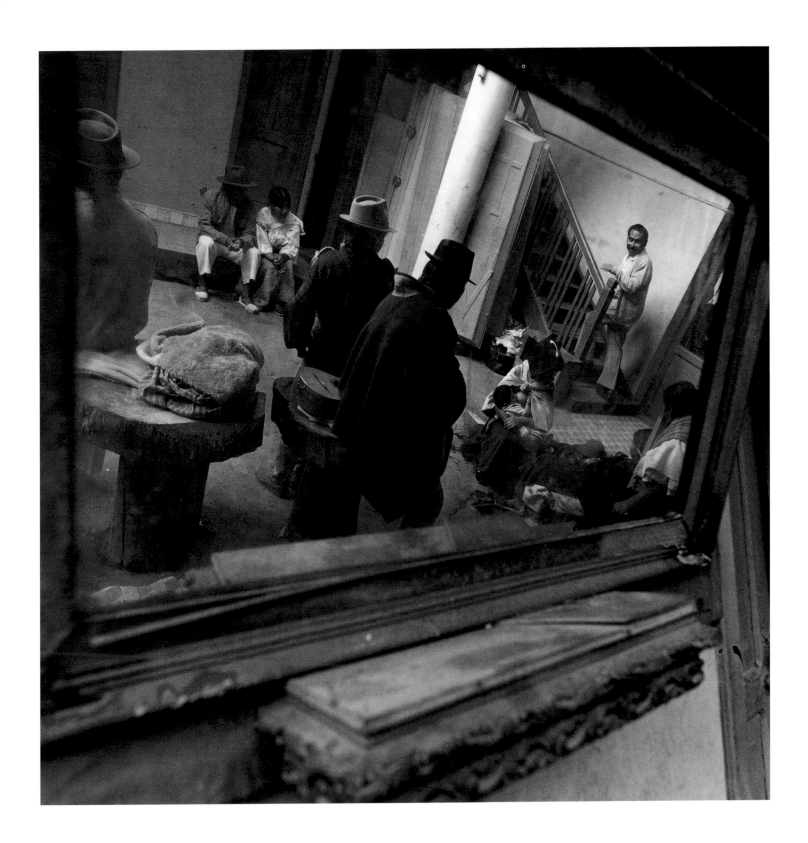

29. Corte de Pelo
Lima, Perú 1991

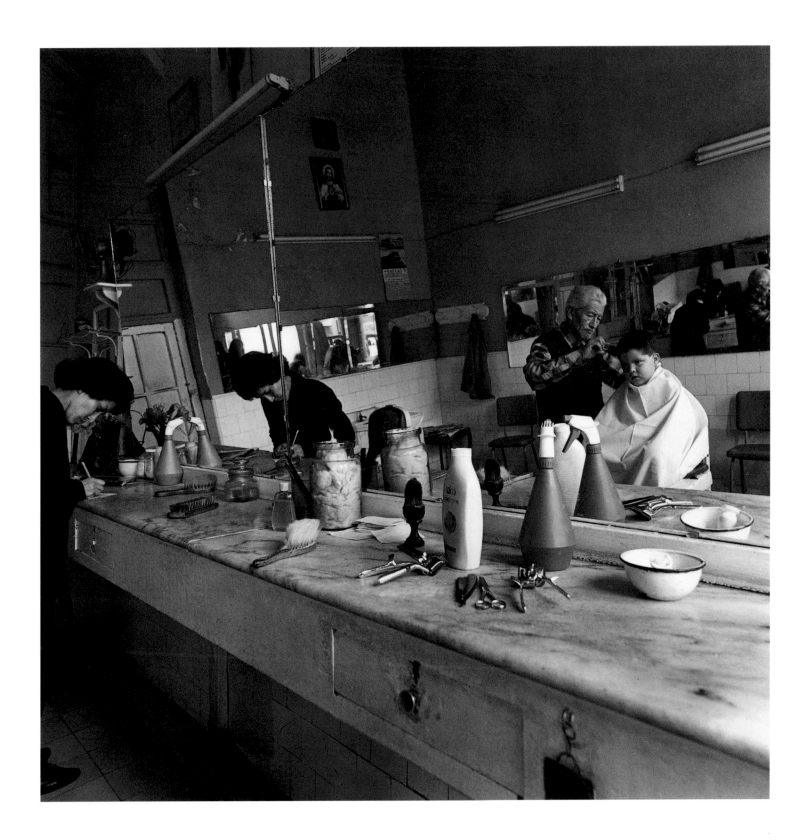

30. No me descuides, infiel
Buenos Aires, Argentina 1984

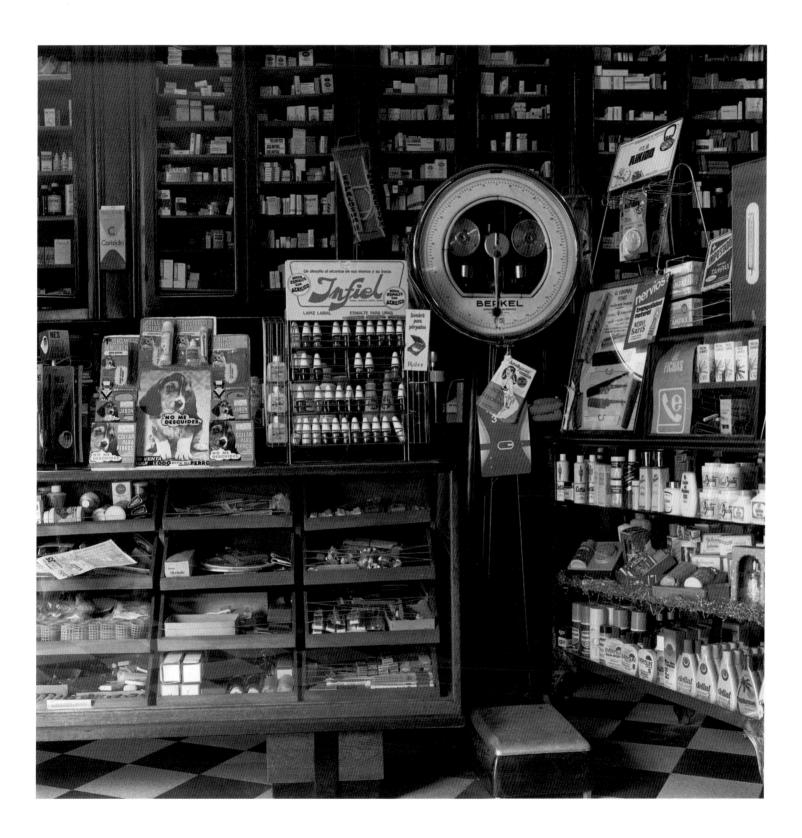

MARIO ALGAZE

Born: Havana, Cuba, 1947 (US Citizen)

Professional Activities

1971 - present Freelance photography in journalism
1979 - 1981 Owner/Director of Gallery Exposures,
 Coral Gables, FL

Selected Exhibitions (* indicates solo exhibitions)

1997 * Throckmorton Fine Art Gallery,
New York, NY

"American Voices," Smithsonian International Gallery,
Washington, DC. Curated by Ricardo Viera

"Once removed: The Photograph in contemporary Cuban-
American Art," California State University. Curated by Tom Callas
and Linda Centell

1995 "Magic Moments: 40 Years of Leica M," traveled to New York,
Paris, Milan, Tokyo, Cologne, Bath, Vienna, Montreux,
Luxembourg, Oslo, Beirut, Frankfurt

"Cintas Fellowship Exhibition," Southeast Center of Photography,
Daytona Beach, FL

* Fundación Guayasamín, Quito, Ecuador, sponsored by the
Alliance Française

1994 "Portfolio Latinoamericano," Houston Photo Fest, Houston, Texas.
Curated by Ricardo Viera

1993 * "Portfolio Latinoamericano," 2. Internationale Fototage, Herten,
Germany. Sponsored by AGFA and curated by Michael Koetzle

1992 * "Film Festival Portraits," Ambrosino Gallery, Coral Gables, FL

"1991 SAF/NEA Regional Fellowships in Photography," Savannah
College of Art and Design, Savannah, GA

1991 "Cuba - USA: First Generation," curated by Fondo del Sol Gallery,
Washington, DC, opened at the Museum of Contemporary Art,
Chicago, IL (traveled to Art Museum, Florida International
University, Miami; Minnesota Museum of Art, St. Paul, MN)

* "Portfolio Latinoamericano," curated by Ricardo Viera, opened at
the Guayasamín Foundation, Quito, Equador (traveled to Lowe Art
Museum, Miami, FL; Art Galleries of Lehigh University, Bethlehem,
PA; Museo Rayo, Roldanillo, Valle, Colombia; Art Museum of the
Miami University, Oxford, OH; Nanette Richardson Gallery, San
Antonio, TX; Norton Gallery of Art, West Palm Beach, FL)

"Traveling," Dunedin Fine Art Center, Dunedin, FL

"Director's Choice," South Florida Cultural Consortium Artists Fellowship Recipients, Norton Gallery of Art, West Palm Beach, FL

* "An Exercise in Color," Barbara Gillman Gallery, FL

* "40 Images," L'Alliance Française au Pérou, Lima, Perú

"Other Times, Other Places," Main Library, Miami, FL

1990 "Twenty-Five in Miami," Art Gallery, Miami-Dade Comm. College, So. Campus, Miami, FL

"Fact and Fiction: the State of Florida Photography," Norton College of Art, West Palm Beach, FL (traveled to Museum of Fine Arts, St. Petersburg, FL; Florida State University Fine Arts Gallery and Museum, Tallahassee, FL; Center for the Fine Arts, Miami, FL; Pensacola Museum of Art, Pensacola, FL)

1989 * "Caras," Cuban Museum of Arts and Culture, Miami, FL

"South Florida in the Eighties," North Miami Center of Contemporary Art, North Miami, FL

"Four Florida Photographers," Stein-Gillman Gallery, Tampa, FL

* "45 Imágenes," Museo de Antioquía, Medellín, Colombia

* "El Sur," Fundación del Banco del Comercio, Lima, Perú

"Six in Florida," North Miami Museum of Art

1988 "Of People and Places," Milwaukee Art Museum, Milwaukee, WI (traveled to the Tampa Museum of Art in 1989)

"Photo Glimpses of Hispanic Culture," Broward Community College, Art Gallery, Ft. Lauderdale, FL

"The Image Makers," Museum of Modern Art of Latin America, OAS, Washington, DC

"Eight from Outside of Cuba," Barbara Gillman, Miami, FL

1987 * "Sur," Miami Dade Community College, North Campus, Art Gallery, Miami, FL

"Outside Cuba/Fuera de Cuba", "Zimmerli" Museum, Rutgers University, New Brunswick, NJ (traveled to Museum of Contemporary Hispanic Art, New York City; Art Museum, Miami University, OH; Museo de Arte de Ponce, Puerto Rico; Center for the Fine Arts, Miami, FL; Atlanta College of Fine Arts, Atlanta, GA)

"Poetic Visions," Real Art Ways Space, Hartford, CT

"Contemporary Figurative American Photography," Center for the Fine Arts, Miami, FL

"Intentions and Techniques," Lehigh University, Bethlehem, PA

1986 * "Portraits, Miami Film Festival," Cuban Museum, Miami, FL

 * "Portaits, Latin American Intellectuals," Books and Books, Coral Gables, FL

1985 * "The Artist as a Theme," INTAR Latin American Art Gallery, New York, NY

 "The Art of Miami," SECCA, Winston Salem, NC

 Group exhibition of gallery artists at Gemini Gallery, Palm Beach, FL

1984 * "Little Havana Series," Barbara Gillman Gallery, Miami, FL

 * "Fifteen Recent Images," Coral Gables Public Library, Coral Gables, FL

 "Hortt Memorial Exhibition," Museum of Art, Ft. Lauderdale, FL

1983 * "Spirit of Place," Miami Dade Community College, North Campus, Art Gallery, Miami, FL (traveled to Lehigh University Art Gallery, Bethlehem, PA, in 1984)

 Solo exhibition, Light Factory, Charlotte, NC

1979 "Cuban Photographers," Washington Project for the Arts, Washington, DC (traveled to Camerawork, San Francisco, CA)

1977 * "17 Imágenes," Sociedad Española de la Florida, Miami, FL

1974 * Solo exhibition, Bacardi Art Gallery, Miami, FL

Art Center College of Design
Library
1700 Lida Street
Pasadena. Calif. 91103

Public and Corporate Collections:

Museo Cuevas, Mexico City
Museo Rayo, Roldanillo, Colombia
Milwaukee Art Museum
Museo Tamayo, Mexico City
Santa Barbara Museum of Art, California
Archer M. Huntington Art Gallery, University of Texas/Austin
Norton Gallery of Art, West Palm Beach, Florida
Museo de Antioquia, Medellín, Colombia
Fundación Guayasamín, Quito, Ecuador
Jane Voorhees Zimmerli Art Museum, Rutgers University, New Jersey
Lehigh University, Bethlehem, Pennsylvania
Ft. Lauderdale Art Museum
Lowe Art Museum, University of Miami, Coral Gables
Miami University, Miami, Ohio
Daytona Beach Community College, Florida
Cintas Foundation Collection, Florida International University
Art in Public Places, State of Florida
Art in Public Places, Miami
Miami Public Library System
L'Alliance Française au Pérou, Lima, Perú
Eastman Pharmaceuticals, Pennsylvania
American Express, Latin America-Caribbean Division
Citicorp, Miami
Leica, Solms, Germany
A.G. Edwards and Sons, St. Louis, MO
U.P.S., Atlanta, GA
Nortel, Latinamerican, Caribbean Division
Carrier, Latinamerican, Caribbean Division

Awards and Grants

1992 NEA Fellowship in Photography
1991 The South Florida Cultural Consortium Visual Artists Fellowship,
 sponsored by the NEA
 Southern Arts Federation Artist Fellowship, sponsored by the NEA
1989 Cintas Foundation Fellowship in Photography, Institute of
 International Education, United Nations
1985 Florida Arts Individual Fellowship Grant

79

3.2008, D.A.P., 40.00, 7/1/95